HOW TO TAKE TAKE AMAZING PHOTOS

LOM
ART

PHOTOGRAPHY AND TEXT
BY NICHOLAS GOODDEN

• •

EDITED BY JOCELYN NORBURY
AND IMOGEN CURRELL-WILLIAMS

DESIGNED BY DERRIAN BRADDER

COVER DESIGN BY JAKE DA'COSTA

First published in Great Britain in 2023 by LOM ART,
an imprint of Michael O'Mara Books Limited,
9 Lion Yard, Tremadoc Road, London SW4 7NQ

 www.mombooks.com/lom

 Michael O'Mara Books

 @OMaraBooks

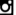 @lomart.books

 @nicholasgoodden

A CIP catalogue record for this book is available from the British Library.

ISBN: 978-1-912785-75-9

1 3 5 7 9 10 8 6 4 2

This book was printed in China.

CONTENTS

· ·

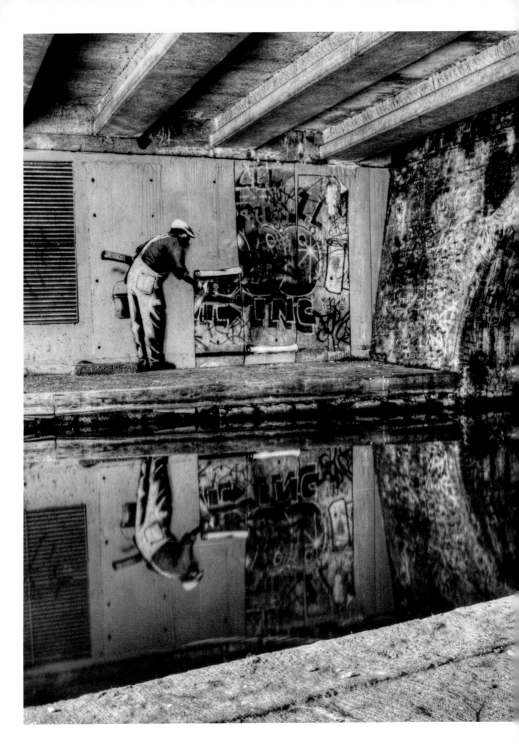

INTRODUCTION

This book identifies some of the fundamental techniques you can use to elevate your photographs from the ordinary to the extraordinary – ensuring they will stand out from the crowd.

From composition to colour choices, light painting to motion blur, each section explores an exciting skill you can immediately put into practice, regardless of where you are or what camera equipment you are using.

A selection of my own photographs has been included to give you a feel for the techniques being discussed, helping you to understand the results you can achieve. I also share tips and tricks to help you think more creatively when it comes to taking your next photo, from looking for new angles to finding inspiration where you least expect it.

Within each chapter, one of my photographs is accompanied by an in-depth, step-by-step breakdown of the techniques and considerations that helped me capture the image, with advice on how you can achieve a similar shot.

When I first picked up a camera in 2008 it was to photograph the graffiti and street art that I discovered around London. Increasingly, I became more interested in the act of photography itself rather than the graffiti I was documenting. Over the years, I immersed myself in the world of photography; buying books, reading articles and spending a lot of time practising my skills.

This book brings together everything I have learnt in the hope that my techniques will help you develop a passion for photography and the skills you need to take your own amazing photos.

NICOLAS GOODDEN

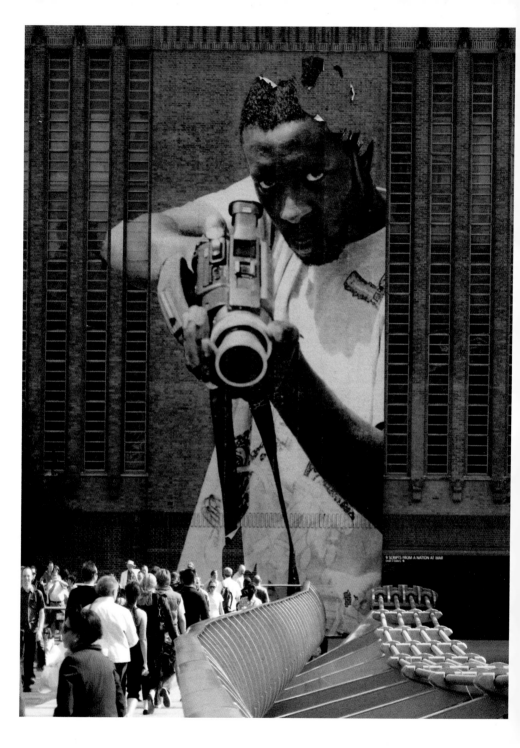

SHOT FROM THE STREET

Street photography has been around for as long as cameras have existed – a result of the photographer's urge to capture life as it happens.

The art of immortalizing a fleeting moment in a public space, street photography is not limited to 'the street'. It can be practised on the subway, in museums and galleries, in an airport, even at the seaside. If you are documenting life as it happens, without interfering by setting up the shot, then you can call yourself a street photographer.

There are many different styles to explore within street photography. You could choose to capture humorous situations, focus on tender moments between people or emphasize compositional elements, such as background or colour contrasts.

This makes it perfect for budding photographers, as it requires no specialist camera equipment. One of its biggest challenges is overcoming self-consciousness.

The fear that someone might not want to be captured by your lens is very real, however, there are ways to work around this. A smile can go a long way!

The art of immortalizing a fleeting moment in a public space, street photography is not limited to 'the street'.

GET THE SHOT

1. FIND AN UNUSUAL PERSPECTIVE

Photographing through a window can offer many benefits, chiefly being able to shoot strangers from a slightly removed point of view. It can be a useful way to get a taste for street photography. In order to stand out from the crowd, a photographer should aim to shoot unique images which can't be easily copied. This photo was shot from inside a famous diner that served fantastic hotdogs. The diner, along with the lettering on the window, is now gone, making this photo even more special.

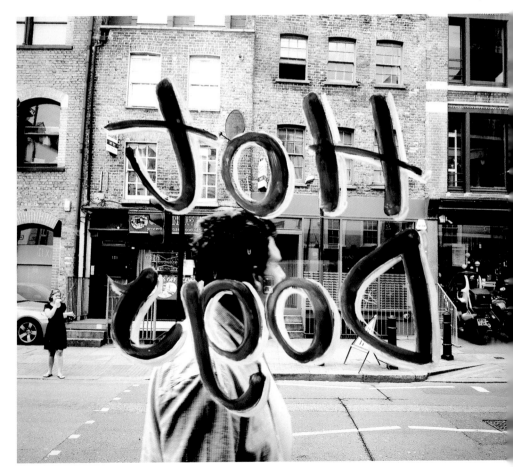

2. PROVIDE INTEREST FROM FRONT TO BACK

In the foreground of this image, there is the wording on the window that gives a sense of location. Behind that is the man walking past, and the buildings are in the background. The best images are ones that provide interest at various levels, from the foreground to the background.

3. CROP THE IMAGE

Cropping is one of the easiest techniques for you to direct the viewer's focus to a specific point of interest in the image. This image is almost square in format, so your eye is immediately drawn to the focus of the photograph.

On a phone, cropping is as simple as opening a photo and selecting the built-in photo editor, then choosing from the preset crops – 16:9 gives a cinematic look, or try a classic square format to help focus your image.

4. ADD A FILTER

In this image, a blueish-green filter has been added to give a unique atmosphere. Adding a subtle colour filter makes the image feel different to an original image, without being too obvious or distracting.

Using filters is a touchy subject among photographers. Should street photography be filter-free? Remember not to let others dictate your creative direction. If using effects stimulates your creativity and improves a photo (at least in your eyes), then there should be no guilt. Filters are often built-in to cameras and mobile phones. Just keep in mind that in photography less is often more.

> The best images are ones that provide interest at various levels, from the foreground to the background.

EXPERT TIP

Shooting with a great camera is always going to help your photographs, but for street photography a camera phone is just as sharp a tool. A smartphone has two main benefits over a traditional camera: one, you'll usually have it with you, and two, phones aren't as conspicuous, so you might not feel so self-conscious getting it out and snapping away. This also helps if you want subjects to remain unposed and unaware of your presence.

Try out these assignments and discover how <u>varied</u> street photography can be.

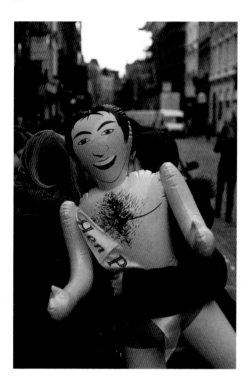

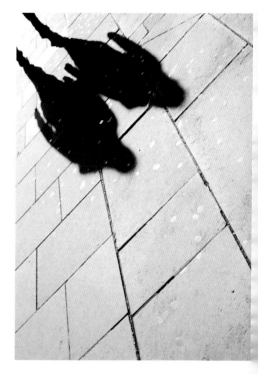

FIND IT FUNNY

Chances are that if something makes you smile, it will make others smile too. A good street photographer will be able to spot opportunities for humour, while always being careful not to make fun of their subject.

The biggest challenge is being ready to capture a shot whenever it presents itself. Know your camera and have it to hand so you don't miss your chance.

START AT GROUND LEVEL

An unusual angle can achieve a fresh image. Here, the long shadows cast by the late-afternoon winter light are interesting. Moreover, making them the sole focus avoids having people's faces in shot.

A different way of looking at the world may bring you the perfect photo opportunity. Start at your feet and who knows?

MAKE IT MINIMAL

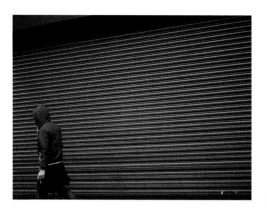

A minimalist image can be just as powerful as a busy, crowded scene that has lots of elements crying out for attention. Make use of 'negative' space (the empty area surrounding your subject) to make a subject stand out.

Look for a bright, bold background colour that will grab the viewer's attention. This will spark their imagination and allow them to wonder about the story behind the shot.

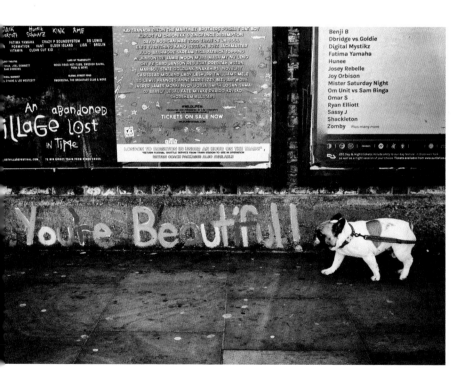

ANIMAL MAGIC

Street photography isn't only about people. Look for opportunites for fun and endearing photographs like the image above, where it appears as though a positive affirmation is aimed at a passing dog. If you want more inspiration, Elliott Erwitt is a master of street photography and is famous for his images of dogs.

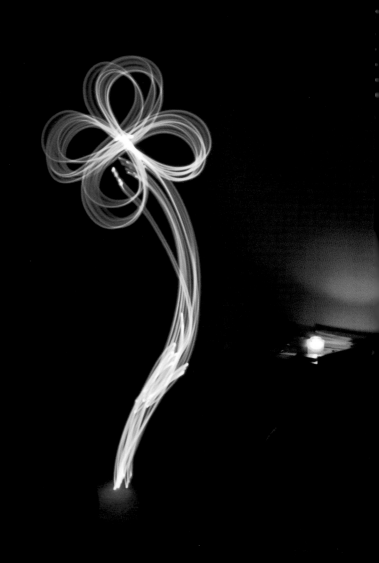

ILLUMINATE YOUR LIFE

PAINTING WITH LIGHT

You could say that all photography is light painting, as the word 'photography' itself literally means 'to draw with light'.

Also known as 'light drawing' or 'light graffiti', light painting is a term generally used to describe capturing light trails or movements of light with a camera set on a long exposure, using a slow shutter speed. 'Long exposure' means keeping the shutter of the camera open for longer than usual. It is a versatile and creative genre, with lots of potential light sources, and can be as simple or as complicated as you want to make it.

But how does it work? Whether it's the middle of the day or the dead of night, everything reflects or emits light to a certain degree. This is what the camera sensor captures when the shutter is pressed. The darker the conditions, the longer the shutter needs to stay open in order to capture the same amount of light, which leads to images with visible 'light trails'. The long exposure allows your camera to capture motion in a blur, while stationary objects stay crisp. In the case of light paintings, the element in motion is the light source.

You can use a basic camera phone or a professional camera to photograph anything from LED lights to fireworks. Glow sticks, flash lights, battery-powered fairy lights and sparklers are just a few things that work brilliantly.

Light painting is a term generally used to describe capturing light trails.

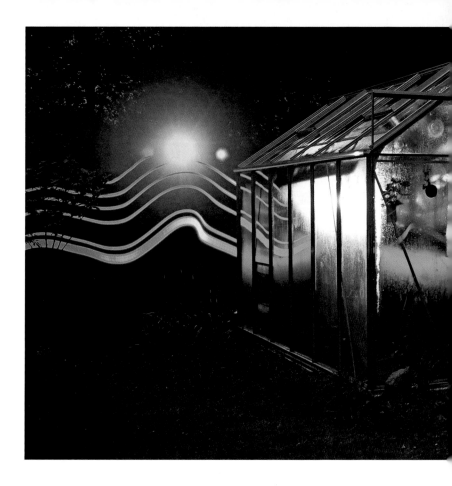

GET THE SHOT

1. SET UP A TRIPOD

When using a long exposure, a stable tripod is a must to avoid motion blur or shake. If you don't have a tripod, place your phone or camera on a stable surface. This will ensure that your scene is crisp and sharp and that the only motion comes from your light source.

2. CHOOSE A LIGHT SOURCE

Light painting doesn't need a professional lighting set up. In this image, running through the frame while waving green glowsticks up and down was enough to create an eerie, supernatural feel.

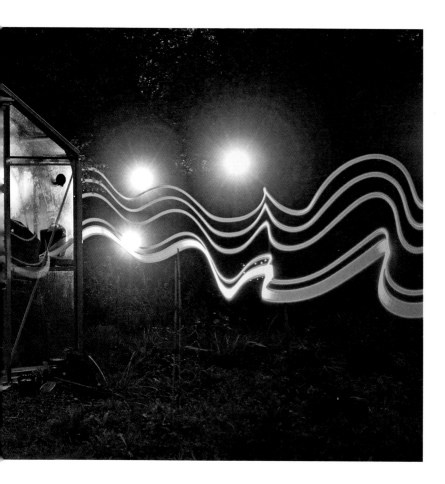

. USE A LONG EXPOSURE

se your camera or phone's shutter
riority mode, which will allow you
 set a long exposure. Try five to ten
econds as a starting point, which
ou can adjust as necessary.

. SET A TIMER

sing a timer for long exposure
hotography helps avoid camera shake
hen pressing the shutter button. It
lso allows a photographer to be their
wn model or subject. You can press
e button, then run into the frame
 move your light source around.

5. KEEP EXPERIMENTING AND PERSEVERE

Start simple. Take some test shots
moving a torch from left to right.
As you understand the technique
more and more, play with different
exposure lengths, different light
tools and shapes, as well as
different concepts and locations.

Light painting always looks (impressive,) eve if the techniques used are super simple.

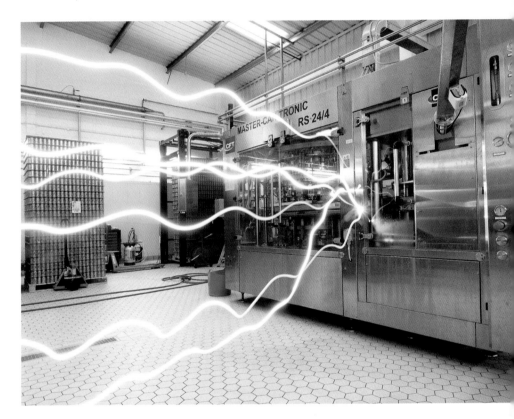

WATCH SPARKS FLY

Create electricity sparks or lightning effects using a pocket LED flashlight.

To achieve this effect in the daytime, you will need to use a neutral density (ND) filter, which allows long exposure times to be used in lighter conditions. Select a ten second exposure and use

the flashlight to draw electric beams back and forth from the point of origin.

If you want to use a camera phone, or just prefer not to use a filter, then this technique can be recreated in the dark, without an ND filter and using the same ten second exposure time.

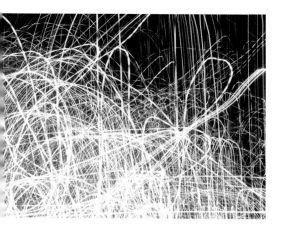

TURN THE TECHNIQUE ON ITS HEAD

Forget the tripod and find a static light source – in this case, traffic stopped at an intersection. Move the camera in a gentle pattern with the camera set on a long exposure – about one to three seconds. You'll see a simple shot transformed into an abstract work of art.

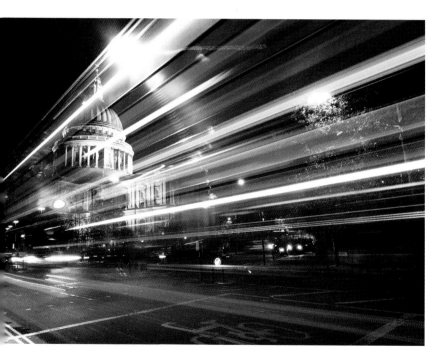

THINK ABOUT BACKGROUND

One key feature of light painting is that the finished image usually only shows the lights, with the light source itself disappearing. This means you have the ability to overlay an interesting background with a vibrant light show. Here, traffic light trails feature prominently in the foreground and partially obscure the background.

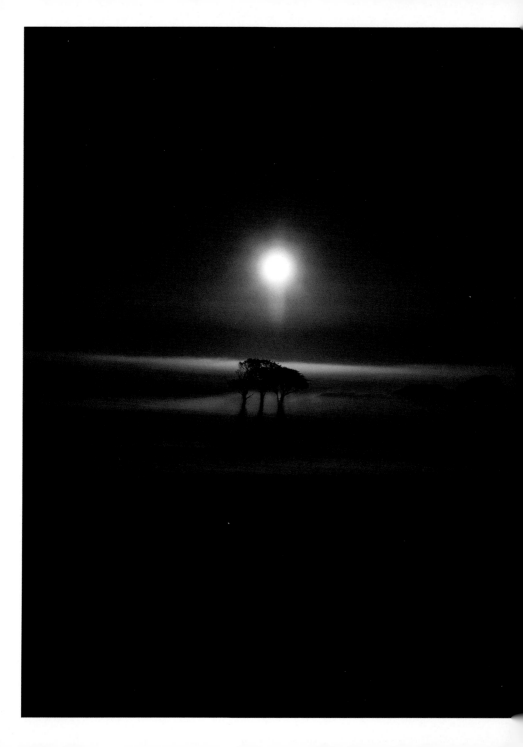

LET'S GO OUTSIDE

NATURE PHOTOGRAPHY

Nature photography is the act of capturing anything which isn't a human creation, but instead is a part of the natural world. Nature photography plays a key part in raising awareness of the fragile beauty of our planet and the importance of preserving it for future generations. When you capture nature, you are capturing a split second out of millions of years of evolution.

When you start to look to the natural world for inspiration, you can open up an endless supply of fascinating and diverse photography opportunities.

Nature photography is a broad subject and many photographers like to specialize within this topic. Some spend their lives capturing fungi, others focus on plants or animals. Some want to discover the infinitely small through macro photography, while others want to showcase the immense beauty of it all through wide-angle landscape photography.

Whichever discipline you choose, nature photography fosters an increased sense of connection to our planet and a desire to protect it. You may even have a feeling of always wanting to see, experience and capture more.

When you start to look to the natural world for inspiration, you can open up an endless supply of fascinating and diverse photography opportunities.

GET THE SHOT

1. AIM FOR STILLNESS

A challenge of nature photography is to avoid unintentional motion blur. Outside, wind can play a big factor. If you're planning to take some photos outside, aim for still days, especially for close-up images. Another reason you may get motion blur is through your own movement. Try bracing yourself against something solid, or use a tripod.

2. SET THE MOOD WITH GREEN

Nature provides an abundance of green, which has a calming, uplifting effect. Experiment with filling the frame with as much green background as you can, limiting other colours, so the focus is primarily on the subject of the shot, in this case the insects.

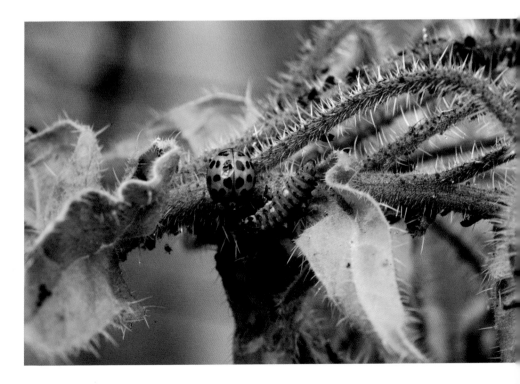

3. PRACTISE WITH SLOW SUBJECTS FIRST

Choose your subject carefully. Start with subjects that move slowly, such as snails, or ones that don't move at all, such as fungi. When you feel confident with your ability to capture these things without unintentional blurring, have a go with faster-moving subjects.

4. POSITION YOUR SUBJECT WITHIN THE FRAME

Close-up photography often results in what is called 'vignette' in the corners of the frame. Vignette manifests itself as a darkening of the photo's corners. This can be used creatively to highlight the centre of the image, as it helps the viewer focus on the subject. Add the contrasting colours of the insects, and these are ingredients for a striking image.

5. EXPERIMENT WITH FOCUS

Focus, as its name implies, not only refers to a specific point of sharpness in the image. It is also a powerful creative tool to help you direct the attention of the viewer where you want it. You're in control. It pays to try different focus points. Whether you use a phone and touch the screen to focus, or a dedicated DSLR camera, changing the focus point can produce surprising results.

Nature provides an abundance of green, which has a calming, uplifting effect.

EXPERT TIP

• • • • • • • • • • • • •

Certain times of the day work better for macro nature photography. Mornings tend to be slower in nature, as well as for humans. Creatures emerge and enjoy the first rays of sun to warm up before springing into action. Mornings also provide a better light, which isn't harsh, and often you'll find mornings to be a lot less windy than later in the day. All this makes for better macro nature shots.

to capture the great outdoors,
landscapes to <u>macro</u> shots.

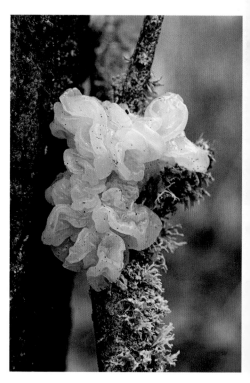

PORTRAITS AREN'T JUST FOR HUMANS

It is possible to create striking portraits of animals, plants and fungi. Take time to find your model, understand the light you are working with, explore different angles, take test shots, and remember to try both colour and monochrome.

COLOUR LIKE ONLY NATURE CAN

Never give up on the hope of finding something to photograph, even during the coldest and shortest winter days. Turn a grey landscape into an opportunity to make something contrast and shine, like this bright yellow fungus.

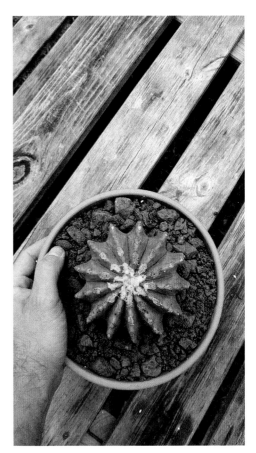

BE AT ONE WITH TREES

Trees are a great subject to use as part of your composition. Whether you capture them close, to highlight their texture and lines, or from afar, they make excellent subjects. Often their natural symmetry helps balance a landscape image.

LOOK FOR INSPIRATION INDOORS

Not everyone has access to wide-open spaces. House plants are a part of nature that most people have easy access to. They make fantastic subjects since they can be so varied in shape, colour and size. What's more, you can practise your nature photography without leaving home.

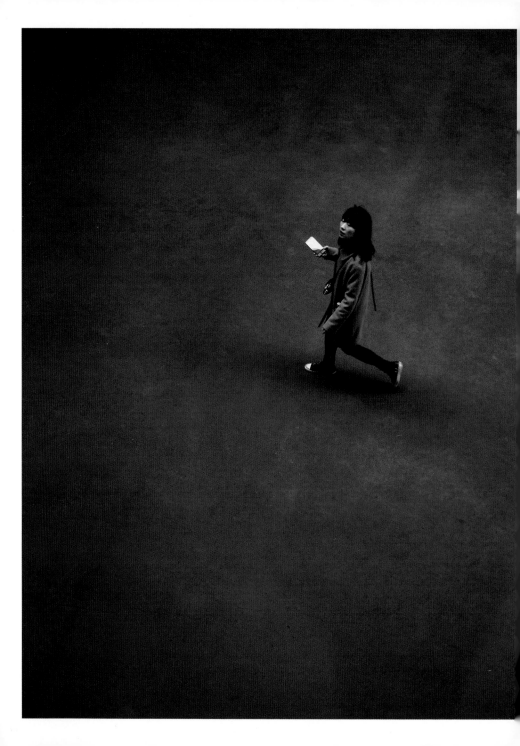

IN THE FRAME

THE RULE OF THIRDS

The 'rule of thirds' is one of the fundamental compositional rules of photography. To follow the rule of thirds, imagine your frame divided into thirds horizontally and vertically, creating a grid with nine parts, just like a game of noughts and crosses.

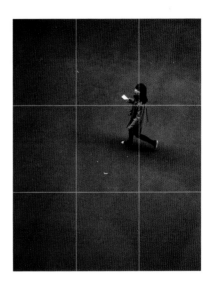

Placing key elements along these grid lines will help to create a natural-looking composition where the focal element is pleasingly off-centre.

To help with composition, most cameras and phones will have an option in the camera settings to display this grid.

As you become more experienced, this element of photographic composition becomes second nature, and something you will be able to apply without a second thought.

The rule of thirds can be seen as a guideline rather than a strict, never-to-be-broken edict. Rules can sometimes limit creativity and exploration, and it is partly through breaking the rules and making mistakes that you can discover new avenues for creativity.

> It is partly through breaking the rules and making mistakes that you can discover new avenues for creativity.

GET THE SHOT

1. LOOK FOR EXISTING LINES

Trees, people standing, architecture, electricity poles, the horizon … all are part of the photograph. Try to align elements within a potential photograph using your imaginary rule-of-thirds grid. In this case, the walls either side of the window split the photo in three fairly equal parts.

2. MAKE IT SYMMETRICAL

Images that make use of both the rule of thirds and symmetry often have a lot more impact. They seem to be processed faster by our brains, which respond well to symmetry. The eye tends to favour a certain visual balance over a messy, imbalanced and crowded image.

3. SHOOT INTO THE LIGHT

By shooting from inside this building, towards the outdoor light, a strong contrast is created and captured. As a result, everything appears as a silhouette. This reduction in what is visible produces an image viewers will be surprised by – it isn't how the human eye interprets light. As a photographer, it is exciting to try and show the viewer something they haven't seen or experienced before.

4. TAKE SHOTS FROM VARIOUS HEIGHTS

In this case, for the sake of straight vertical lines, the image was shot at eye level. Often, whatever you are shooting, it is worth taking a few test shots from different heights. Try one at eye level, one high up at arm's length and one right down by the ground, as low as you can. You will be surprised how much of a difference it makes, and often it is the low angle which is the most exciting and dynamic.

> Images that make use of both the rule of thirds and symmetry often have a lot more impact.

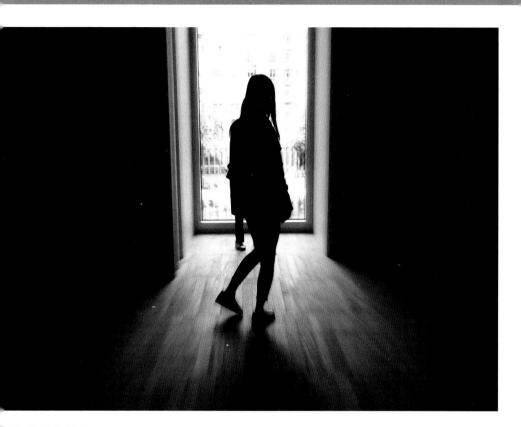

EXPERT TIP
• • • • • • • • • • • • • •

f you're only just getting familiar with photography and the rule of thirds, then it is
useful to set your camera or phone to display the rule-of-thirds grid. Practise aligning
key elements in your frame at the intersection of lines or on the lines themselves.
For example, if shooting a landscape, you might want to place your horizon on the
first line from the top of your frame. If you are shooting a person as well as a landscape,
then place your subject on the first line either from the left or from the right. You may
have to move to achieve this or ask your subject to. This is not the ultimate rule of
photography, but more of a beginner's guide. As with all things, rules can be broken!

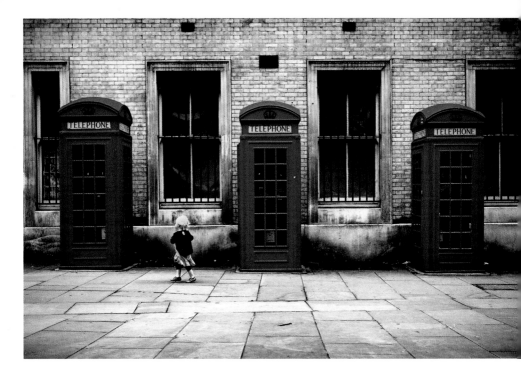

START WITH SYMMETRY

Architecture is an ally. It offers useful, solid lines which can be used to compose and balance a photograph. This can be useful as you can spend as long as you like composing your shot – this grid isn't going anywhere. Find and frame a shot that offers perfect symmetry, then wait for something to come along to break the symmetry.

USE MOBILE ELEMENTS

Try using moving subjects, such as vehicles or people, to construct your 'grid'. Here, the pedestrian, in the opposite third of the grid to the bus, balances the image horizontally.

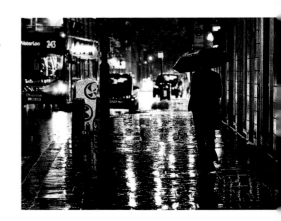

Use this simple compositional technique to help (draw) the viewer into your photographs.

BEND THE RULES A LITTLE ...

Sometimes, it makes sense to work with grid lines that are physical, rather than imaginary.

For an interesting result, seek out a shot that enables you to apply the rule only partially, by splitting the image into thirds vertically, and also in half horizontally.

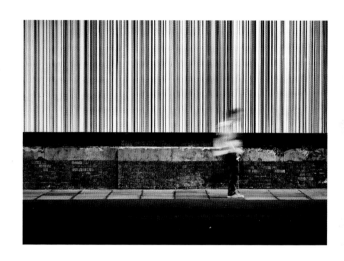

... OR THROW THE RULEBOOK OUT

It is easy to get hung up on rules and think that all it takes for a good photo is to just follow the rulebook.

Rules are secondary if what you capture is special or makes the viewer feel something. What matters ultimately in photography is what's being captured, not so much how it's being captured.

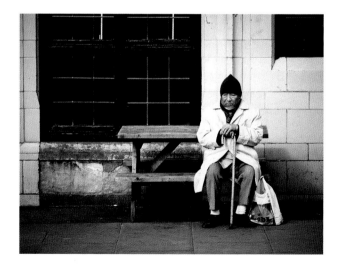

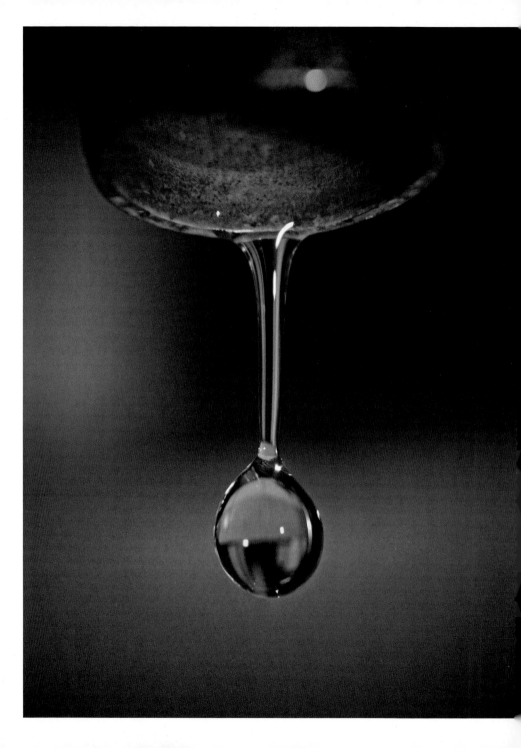

READY FOR A CLOSE-UP

MACRO PHOTOGRAPHY

Macro photography involves shooting in extreme close-up to capture very small details that aren't always obvious to the naked eye.

It is a technique that helps you to discover an entirely new world, wherever you are. The opportunities for the inquisitive photographer are endless and don't require too much to get started. A camera phone and an eye for detail is all that is needed to capture spectacular close-up shots successfully.

Of all genres of photography, macro is one of the most educational and scientific. Often used for nature photography, it gives the photographer a sense of scale, relativity and an understanding that entire ecosystems reside in the very small.

It's not only about nature, however. Macro photography offers many alternative avenues, such as abstract or minimal. The aim of macro photography is to highlight what we otherwise ignore or don't see. But be warned – it's addictive!

Macro is a technique that helps you to discover an entirely new world, wherever you are.

GET THE SHOT

1. POSITION YOUR SUBJECT

Macro is great for creating dreamy scenes. Position your subject so that it makes the most of its surroundings and includes its environment. In this image, the snail is comparatively heavy considering the dainty fennel fronds it is resting on. The snail appears as if it is weightless, floating through a sea of green.

2. LESS IS MORE

Embrace the notion of minimalism. By removing distractions, such as multiple colours or shapes fighting for attention, the viewer automatically looks at the snail, even though it fills only a small part of the image.

3. APPLY NORMAL PHOTOGRAPHIC 'RULES'

Rules are not the be-all and end-all of photography, but they are good to know and apply when appropriate. In this case, using the rule of thirds means the snail was intentionally framed two-thirds from the bottom and two-thirds from the left of the image. The empty space helps to draw the viewer's eye to the focus of the image – the snail.

4. CHOOSE YOUR FOCUS

Depth of field is, simply put, the extent to which everything is in focus within the frame. Shooting closer means a further reduction in depth of field – your subject will be in focus but very little around it will be. Turn this into a creative advantage to give your images that enticing blur in chosen areas.

5. TAKE MULTIPLE SHOTS

This is a recurring tip because it is one of the best ways to get a great shot and become a better photographer. Never settle for a single image. You don't have to take a hundred versions of the same photograph, just shoot a few images, then use your creative judgement to decide which has the most impact, the best focus and the best composition. This comparison is how you can begin assessing your work.

Rules are not the be-all and end-all of photography.

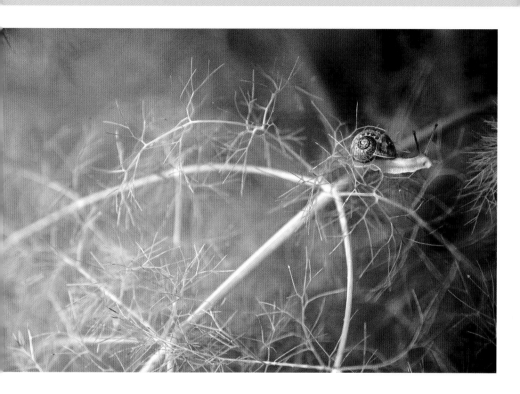

EXPERT TIP

· · · · · · · · · · · · ·

For the best results in macro photography you need plenty of light and camera stability to get sharp shots and not blurry ones. It is possible to use your phone's flashlight to illuminate the scene a little. Bring your phone or camera closer or further from your subject and vary the angles the light comes from to find the sweet spot. For stability, either rest your camera on a hard surface or lean against some support … or even better, use a tripod.

A whole new world awaits when you (focus) in on the smallest details.

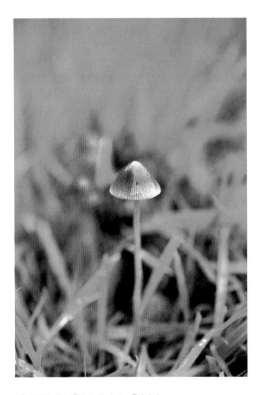

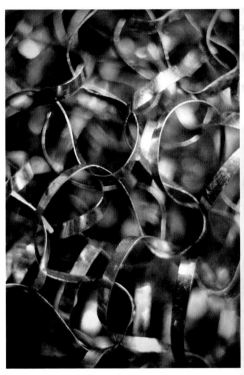

GET DOWN LOW

Anything at ground level is bound to offer surprises as it is so far from our usual line of sight.

Whether you're on a city street, out in nature or in your own home, explore the ground, looking for hidden opportunities – things you've never noticed before or have never stopped to observe in detail.

ABSTRACT WORKS OF ART

In extreme close-up, even seemingly uninteresting objects offer potential for beauty.

In this case, a kitchen scourer became a work of art when photographed close-up and with the right angle and light.

EXPLORE CONCEPTUAL PHOTOGRAPHY

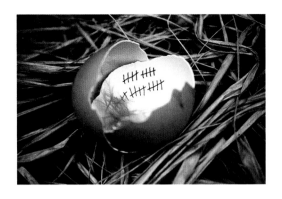

Conceptual photography is about bringing an idea or concept to life through an image. Here, an eggshell inspired the idea of a chick counting down the days before it hatched. The camera has focused on the conceptual part – the countdown – to draw the viewer's attention to it. The most difficult part of conceptual photography is finding the inspiration. Be sure to keep an open mind – every object around you has the potential to become part of your art.

SET UP A MINIATURE SCENE

The trend of using model figurines was made popular by international street artist Slinkachu, who creates and photographs miniature scenes in city streets for people to find.

To try it yourself, find everyday objects and pair them with small-scale figures to create humorous, and confusingly real, macro photographs.

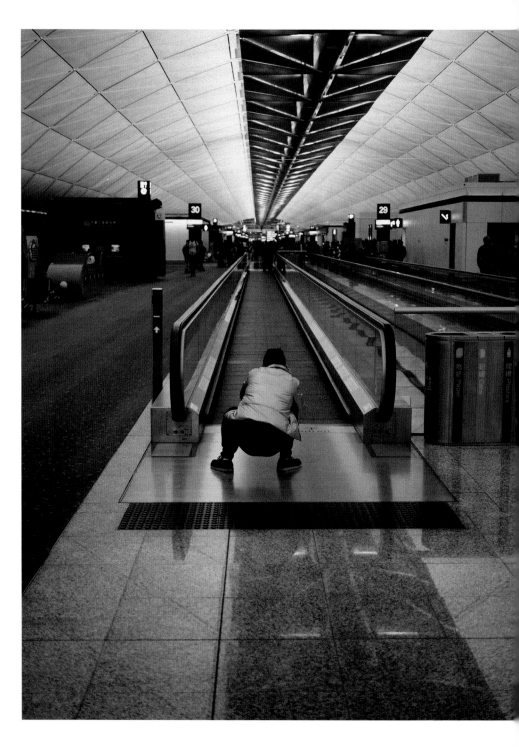

HOW LOW CAN YOU GO?

LOW-ANGLE PHOTOGRAPHY

One of the biggest joys in photography is looking for new angles or perspectives that allow you to shoot something unique, or at least in a unique way. It can be challenging, but when you succeed it's a great feeling.

Lowering the angle at which you shoot is one of the easiest and most effective ways to produce original, exciting and dynamic shots. It presents a fresh perspective to the viewer, who is otherwise used to seeing the world from a human perspective and height.

Using a low angle shifts the perspective of the image you create and adds new dimensions. It can make your subject feel bigger and more impactful, as well as introducing the viewer to a perspective they aren't used to. For example, from a child's height or a small animal's.

Whether you use a phone or a camera makes little difference – don't let gear be your limitation. Get creative in how you see the world around you.

Whether you use a phone or a camera makes little difference – don't let gear be your limitation.

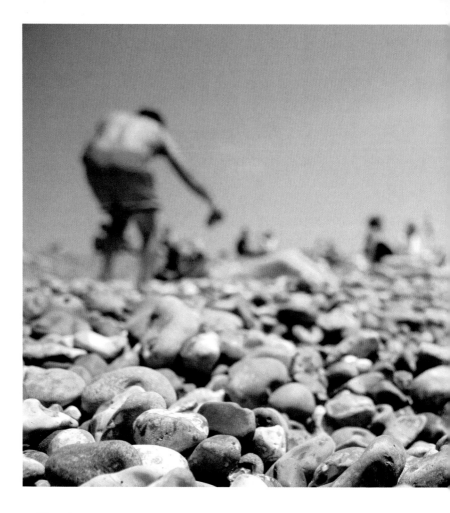

GET THE SHOT

1. CHOOSE YOUR SUBJECT

Focusing on a point of interest in the foreground, like these pebbles, often works best when shooting low angle, as it creates an interesting sense of depth and scale. This simplifies the composition, makes it feel less busy and helps to achieve an 'insect's view' image.

2. GET IN POSITION

Because we're not used to seeing the world from this height, it took me lots of experimentation and test shots from various angles before realizing that lying completely flat was the best option.

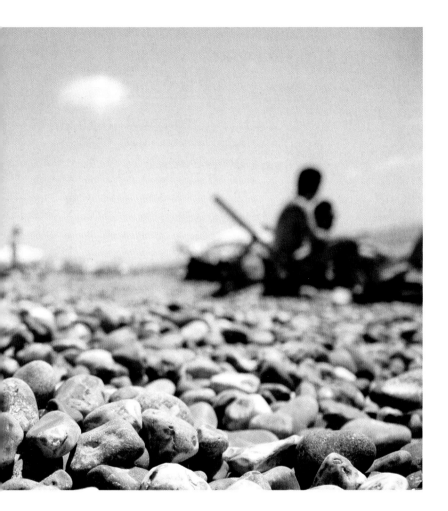

3. CHECK YOUR EXPOSURE

Because of the bright daylight, the camera could only properly expose either the sky or the foreground.

Here, the foregound was chosen as the subject, so the pebbles are sharp but the sky appears bright and blurry. If the focus had been the sky, the pebbles would have appeared dark and silhouette-like, instead.

4. ADJUST THE DEPTH OF FIELD

A shallow depth of field was used to achieve this blurred background. Position the subject as close as possible to the lens, making sure your camera or phone isn't too close to focus. If it is, gradually pull back until you achieve a clear focus on your subject.

5. KEEP IT LEVEL

Take an extra second to ensure your camera is level. Then, click! You've got your shot.

Use the ideas below to experiment with the low-angle technique, wherever you are.

FIND SOME LEADING LINES

Leading lines are lines, like the pavement in this example, that naturally draw the viewer's eye towards the key element in a photo. Look for electricity lines, hedges, road markings, railtracks and buildings naturally vanishing into the distance. When you spot them, lower yourself slowly while looking through the viewfinder or screen. This will help you find the perfect angle where the lines are most effective at guiding the eye.

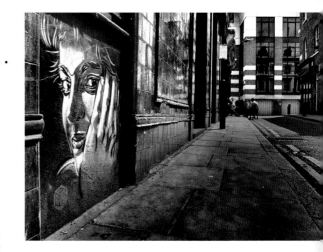

PLAY THE WAITING GAME

Patience is a valuable creative tool. Choose your background and compose a low-angle shot, then wait for interest to walk across the frame. This seemingly giant pigeon adds interest and humour to an otherwise basic photograph.

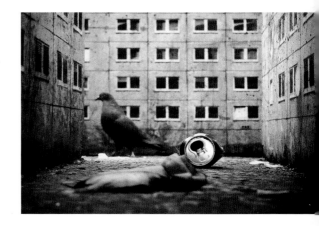

SQUEEZE IN A SKY SCRAPER

· · · · · · · · · · · · · · · · · ·

Shooting architecture from a low angle has many advantages, including being able to fit more in your frame. Whenever you feel restricted by your lens not being wide enough, position yourself as low as you can while tilting your camera up at a 45-degree angle. You will find you can you fit a lot more into the frame and you will get a more interesting shot, too.

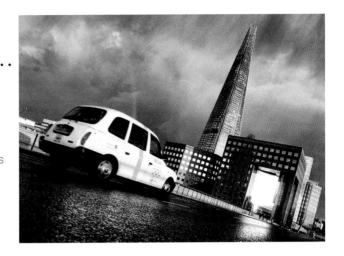

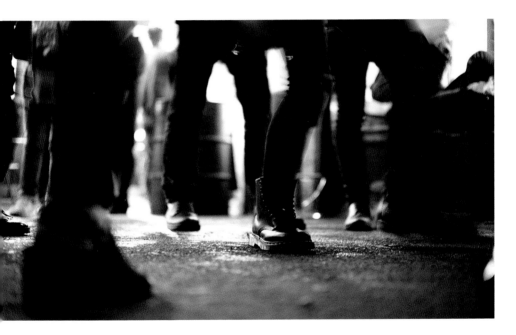

CAPTURE A CROWD SCENE FROM THE GROUND

· ·

Create a strong, minimalist image using a mixture of low angle, black and white and motion blur. Rest your camera on a hard surface to capture movement in the scene. If shooting at night, black and white can work far better than colour, and by showing very little you can capture the viewer's imagination.

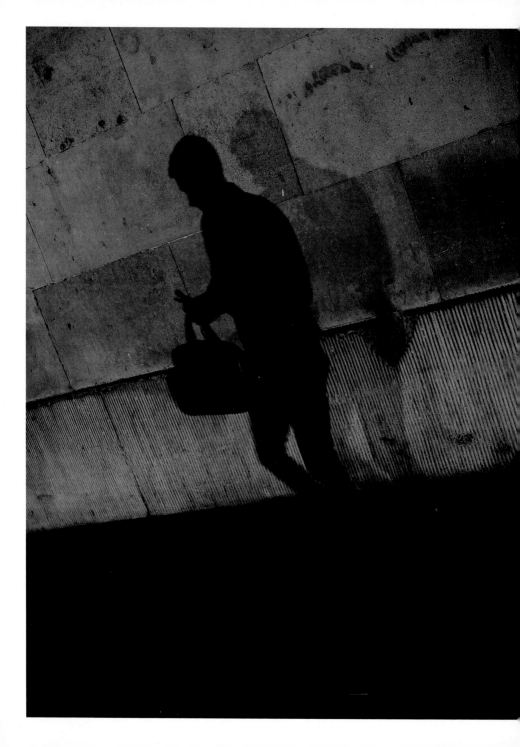

MAGIC IN MONOCHROME

Black-and-white photography is hard to resist for many reasons. It evokes a certain nostalgia, possibly because early photography was without colour. It exudes a certain class when well executed, and changes the mood of a photo which would have felt different in colour.

When capturing your subject, whether it is a person, a street scene or a landscape, colour can often be a distraction from the intended point of focus. Colour screams for attention, whereas black and white makes viewing a little calmer, even though the depth and range of tones is as diverse as in colour.

Shooting in black and white can be a bit of an 'easy trick', making you feel as though a photograph automatically looks better. However, it's still important to consider composition, exposure and choice of subject. Aside from the beauty of monochrome, the photo should still have something that makes it great.

> Colour screams for attention, whereas black and white makes viewing a little calmer, even though the depth and range of tones is as diverse as in colour.

GET THE SHOT

1. EMBRACE MOODY WEATHER

It's easy to be discouraged by less-than-perfect weather conditions, but black-and-white photography is perfectly suited to capturing overcast days.

In this photograph, the weather set the mood and turned a dreary day into a work of art.

2. TILT YOUR CAMERA

Rotating the camera by 45 degrees allowed a lot more to squeeze into the frame and is a good trick to help fit in large subjects, such as buildings. The unusual angle helped the shot to feel more dynamic. The viewer can imagine they are right there on the spot, looking up.

3. LOOK FOR CONTRASTS

Photographs become much more interesting when they include two contrasting subjects, or two different versions of similar things. Here, the industrial metal skeleton of the tower is paired with the organic skeleton of a tree.

4. SEE THINGS DIFFERENTLY

When we're bombarded by numerous images of the same thing, even the most spectacular scene can start to lose its magic. As a photographer, you should aim to capture familiar things in a different way. Find a way that will make people stop, look and appreciate the new perspective offered. Make your motto, 'the same, but different'.

5. COMPARE WITH COLOUR

Always take at least two shots of the same scene, one in colour and one in black and white. It's worth having both options in case the colour version captures details that are lost in black and white.

As a photographer, you should aim to capture familiar things in a different way. Find a way that will make people stop, look and appreciate the new perspective offered.

EXPERT TIP
· · · · · · · · · · · · · ·

Like all things, practice makes perfect. When learning various aspects of photography, don't just apply it once and move on satisfied with one good shot. Instead, try immersing yourself in that style, perhaps telling yourself that one day a week will be dedicated to it, in this case, black-and-white photography. It is only with extended practice that one becomes expert at something and truly develops their own unique style.

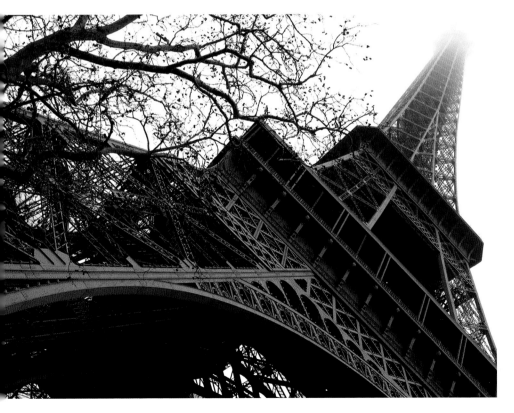

Black and white will <u>never</u> be boring with these creative ideas to try.

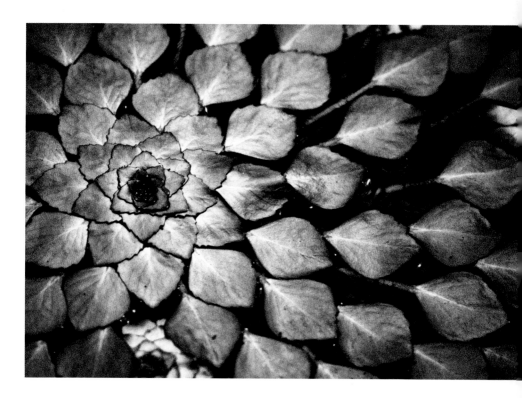

CHOOSE A COLOURFUL SUBJECT

It may seem counter-intuitive, but the beauty of black and white is that it allows us to look at the world in a different way. Here, instead of the riot of colour we would usually associate with plants, we are left to enjoy the intricate texture of the leaves and the patterns they create without distraction.

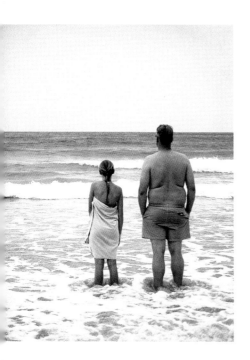

CAPTURE THE DRAMA OF RUGGED LANDSCAPES

Photographing landscapes in black and white can be very powerful. It is as if the natural world wants to be shot without colour. Black and white seems to highlight nature's million-year-old scars and all the natural elements that make humans feel very small indeed.

CREATE A MOOD

This is an example of how black and white sets an atmosphere. Look for a special scene or moment shared between two people. Shooting a black-and-white image can help to capture that moment and tell a story, without even needing to show people's faces.

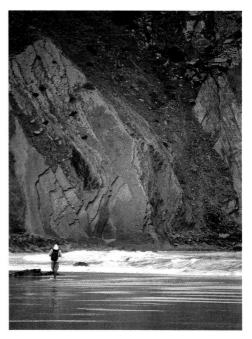

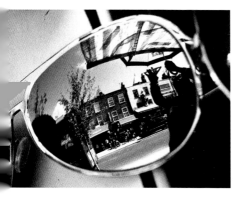

LOOK FOR UNUSUAL REFLECTIONS

You can achieve a vintage look by combining a few elements in the photograph. Here, black and white is combined with aviator-style sunglasses, which frame the shot and reflect buildings that are far from modern. This results in an image that is fairly timeless – it could have been shot in the seventies after all.

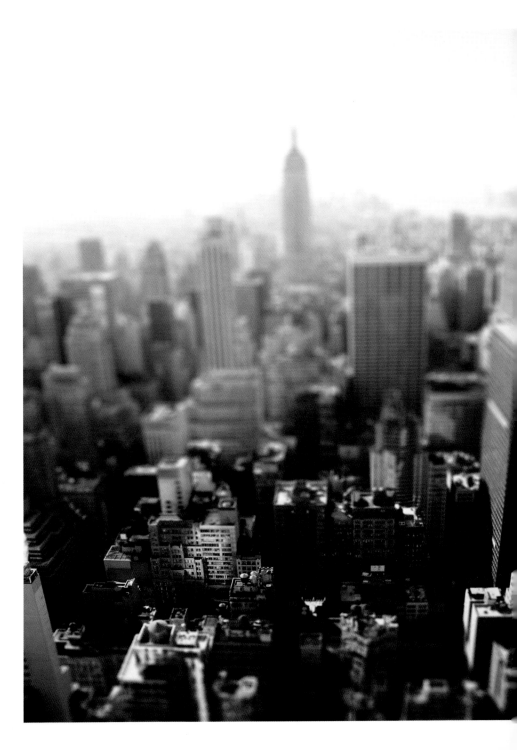

UP, UP AND AWAY

Photography is a tool which enables us to show others the world we live in, from our own unique perspective. This means there are as many ways to see and show the world as there are people.

The element of surprise is often the secret ingredient of a great photograph – when the viewer can look at an image and think 'that's unusual' or 'I've never seen this shot like that before'. Once a photographer understands this, the door is opened to a lifetime spent searching for new angles, better angles and more unusual angles.

Shooting from above has the opposite effect to low-angle photography, which is a great way to easily gain a new, 'ant's view' perspective, where everything looks bigger and more dramatic. In contrast, a high vantage point can give a sense of scale and further establish how small we are.

> The door is opened to a lifetime spent searching for new angles.

51

GET THE SHOT

1. CHOOSE A LOCATION

It is often easier to find an elevated position in an urban environment. Whenever you are on a bridge or in a building, remember to look down. This is where opportunities often lurk. Here, a train station provided an ideal opportunity, as it was so busy that people didn't stop to notice a photographer taking photos from a balcony above them.

2. TAKE YOUR TIME

Walk around and take some test shots from different elevated spots. Once you find the right one, don't accept your first shot. People and crowds are constantly on the move, changing the shot completely from one moment to the other, so you never know what you'll get next.

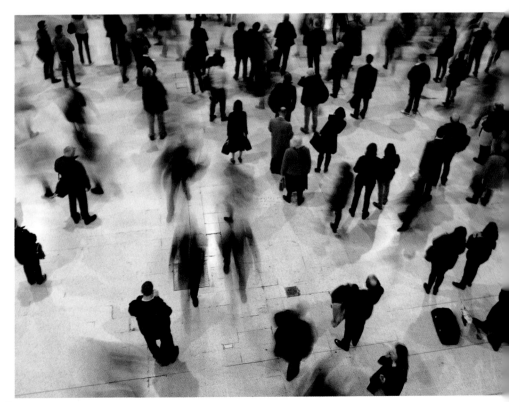

3. COMMUNICATE THE ATMOSPHERE

If this image had been shot with a fast shutter speed, all the people would appear still, which isn't what I wanted want to portray in this instance. To convey movement, use a slower shutter speed. People who are in a hurry appear blurred, but those standing still remain in focus. Gradually reduce the shutter speed, taking a test shot each time, until you are happy with the result.

4. CHOOSE BLACK AND WHITE OR COLOUR

This image was captured in black and white for simplicity, avoiding a mish-mash of clothing colours which might have been distracting. Depending on your subject, colour might be a better option, so always try both.

5. PLAY WITH CONTRAST

Different contrasts are very easily achieved with any free photo-editing app. Select the brightness/contrast option and use the slider to increase and decrease the contrast. You will find that in black-and-white photography, increasing contrast will darken the blacks and remove detail within these tones, as shown here. This can be used creatively to make an image more minimal.

Whenever you are on a bridge or in a building, remember to look down.

EXPERT TIP

· · · · · · · · · · · · ·

Be conscious when you take photographs in a public space, especially train stations or airports. While you are not doing anything wrong, you may still invite questions from overzealous security staff. You would not be the first photographer to be stopped and asked the reason you are standing around, waiting and taking lots of photos. Politely explaining what you are doing should suffice.

There are lots of ways to create fun, <u>experimental</u> shots which all start with looking down.

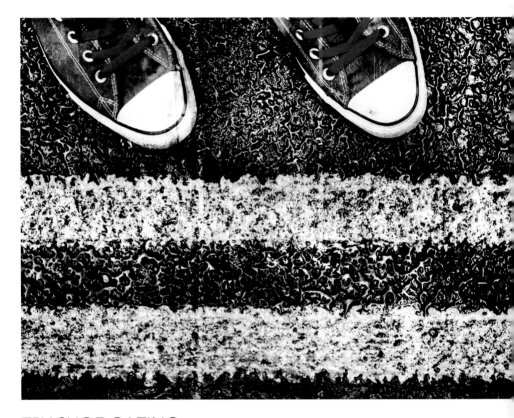

TRY SHOE GAZING

There is so much to be found on the ground. From colourful autumn leaves to sea shells, painted lines on tarmac to tile patterns ... the list is endless. Let these things be the background and make your feet centre stage. You could easily dedicate a whole series to capturing locations based only on what's at your feet. Wear an iconic pair of shoes and you're on to a winner.

BIDE YOUR TIME

This shot was composed without anyone in the frame, using the shadow of the bridge as the main compositional element. Then it was just about waiting and being ready to click. Some attempts were discarded because the subject was shot in the shadow, others were rejected as the person was walking. This shot was selected as the runner was in the right spot to make the image dynamic and interesting.

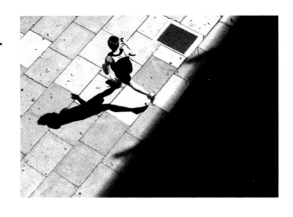

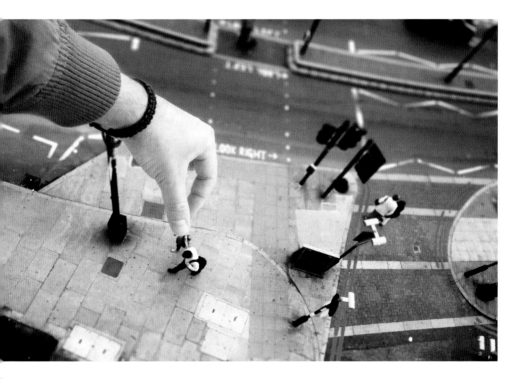

PLAY WITH FORCED PERSPECTIVE

This fun shot was taken from on top of a building, to give the impression of a giant picking up a pedestrian from the street below. This optical illusion is easy to create – the key is to increase your depth of field (the distance between the nearest and furthest elements that are in focus) to the maximum.

THINK NEGATIVE

USE OF NEGATIVE SPACE

In any creative pursuit, be it photography, design or painting, the part played by negative and positive space is of equal importance. Positive space is the space occupied by your subject, while negative space is the empty area surrounding the subject. What matters is finding the right balance.

Think of negative space as breathing room for your eyes, similar to a visual 'pause button'. Too little of it will result in overcrowded photographs in which every element is competing for the viewer's attention. This makes it difficult to know where the focus is supposed to be.

Negative space acts as a buffer, a place where the viewer's eye can rest and easily focus on the subject of the work. This adds definition.

Generous use of negative space often results in more minimal photos – as is often the case, less is more.

Negative space can also add mystery. The viewer is invited to come up with the rest of the 'story', dramatically altering the mood and emotion of a photograph.

Think of negative space as breathing room for your eyes.

GET THE SHOT

1. NEGATIVE SPACE FOR POSITIVE IMAGES

The negative space here is the orange wall, which surrounds the subject. It is possible, with practice, to develop a natural eye for such compositions. For example, the first thing you may want to try in your own photography could be blue sky. Allow it to dominate the space, then look for something to include in the image that only occupies a tiny fraction of it.

2. IT'S ALL ABOUT LOCATION

This image was captured at a modern-art museum. Museums are excellent locations for people and street photography. Rarely overcrowded, they offer calm and shelter from the weather and often have excellent light. A photographer doesn't stand out from other visitors, as lots of people will have a camera, and that is useful for those who are a bit shy but keen to get into street photography.

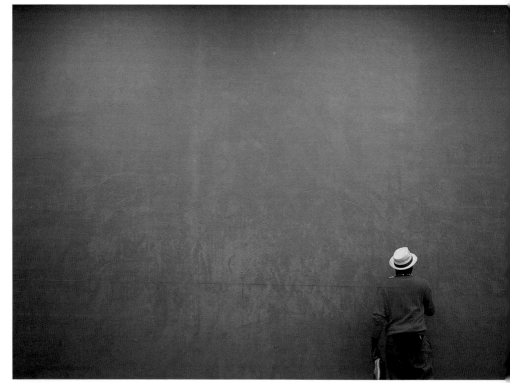

3. EMBRACE BOLD COLOURS

Look for walls or features that make a statement and use them to help your photographs stand out. Playing with big, bright and colourful backgrounds can truly elevate your photographs. This bright-orange wall's appeal was irresistible.

4. WAIT FOR THE RIGHT SHOT

This frame needed a human presence to make a great shot. As it happens, the wall was covered in orange felt, and it attracted people in the museum who wrote messages using their fingers on the fabric.

If you wait long enough, you'll capture someone or something that fits perfectly within your frame. If you wait even longer, you'll capture someone who not only fits well within the frame but also wears a matching jumper. In photography, opportunities come to those who wait.

5. LESS IS MORE

You might not think it, but minimalism has a place in street photography. If you enjoy capturing strangers in a natural environment, play with a minimalist look. This image features so little, with its huge orange wall and a single person in the bottom corner, and yet it is still striking and eye-catching. An image needn't have a lot of elements in it to be impactful.

In photography, opportunities come to those who wait.

Making use of negative space is one way of highlighting that (beauty) can be found in the simplest of set-ups.

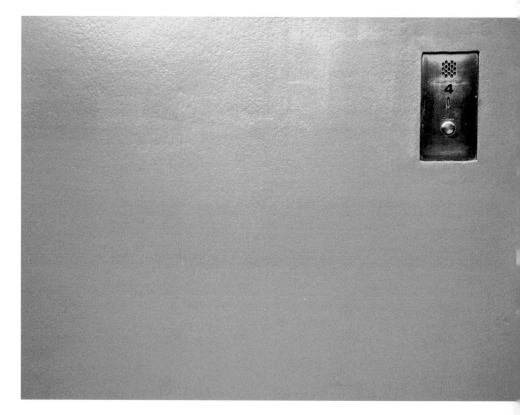

TURN EVERYDAY OBJECTS INTO ABSTRACT WORKS OF ART

When you stop looking at an object for what its function is, you can then use it as part of an abstract composition simply for its aesthetic attributes. Here, the intercom becomes a rectangular metal shape, its gun-metal colour and smooth texture contrasting with the orange-peel textured and coloured wall.

IT DOESN'T ALWAYS NEED TO TELL A STORY

People often think their image has to tell a story, which can feel intimidating. The use of negative space is often more about aesthetics rather than chasing 'meaning'. Find the lines you like and colours that attract you, and play with creating beautiful images simply for the sake of it. Symmetry and geometric lines are everywhere – make these the focus.

COMPOSE IT YOUR WAY

There are as many ways to compose a photograph as there are photographers. There is not really a right or wrong, just different ways to perceive things. It is possible to apply negative space to any type of photography, whether you shoot landscapes, food, street scenes, products or even motor sports. The winning composition is often the one that offers the most contrast.

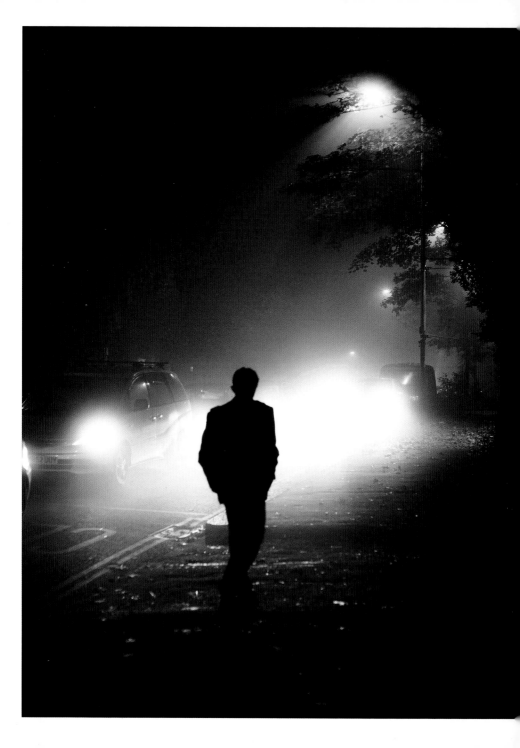

OUT OF THE SHADOWS

USING SILHOUETTES

Making use of backlighting, and the silhouettes that result from it, is a great way to give even the most standard subject a dramatic edge. Thanks to something called dynamic range, the camera 'sees' backlit subjects differently to the human eye, giving them a hyperreal, otherworldly feel.

When taking photographs, skies can often appear very bright or over-exposed, while the darker areas, including people, are left looking shadowy or under-exposed. This is because of the light behind them. Using a flash can help to compensate, but is not a complete solution.

Instead, why not turn technology's limitations into a creative advantage, by creating images with dramatic silhouettes? As long as the background is brighter than the subject, you'll get your silhouette.

> Making use of backlighting, and the silhouettes that result from it, is a great way to give even the most standard subject a dramatic edge.

63

GET THE SHOT

1. MAKE USE OF GOLDEN HOUR

Golden hour is that fleeting moment on certain days, as the sun rises or sets, when the light is warmer and softer than at any other time. Because of the position of the sun right above the horizon, it creates dramatic, elongated shadows.

For the most impactful backlit silhouettes, aim to shoot during golden hour. In this photo, the sun is at a perfect low angle, lighting the subject from behind and creating silhouettes.

2. SET THE SCENE

Look for a location the viewer may be familiar with, a place that evokes feelings of excitement or nostalgia. The airport in this image feels particularly atmospheric – somewhere to be reunited with loved ones, of happiness and anticipation, or of separation. All of these heady emotions can be evoked using this clever trick of the light.

3. CAPTURE LEADING LINES

In this photo, the light helps to create a line from the subject to the photographer, and in turn to the viewer. The camera is facing the light, so the shadows created by the subject inevitably point in the photographer's direction. These shadows create their own leading lines, which take the viewer's eye straight to the subject.

4. SHOOT IN BLACK AND WHITE

Silhouettes are usually best captured in black and white. They produce a minimal image, where colour doesn't distract from or reduce the atmosphere created in the shot.

5. LOOK FOR REFLECTIONS

Do you know what looks better than one silhouette? A double silhouette. This can be achieved using reflection. Reflections don't just have to be in water, either – in this photograph, a polished concrete floor creates enough of a mirror image to balance the photo.

Look for a location the viewer may be familiar with, a place that evokes feelings of excitement or nostalgia.

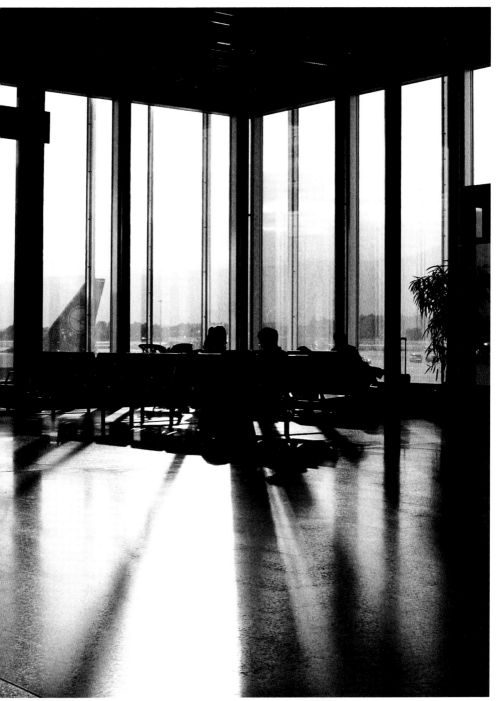

Mix it up using different light sources, angles and backgrounds to create <u>striking</u> silhouette images.

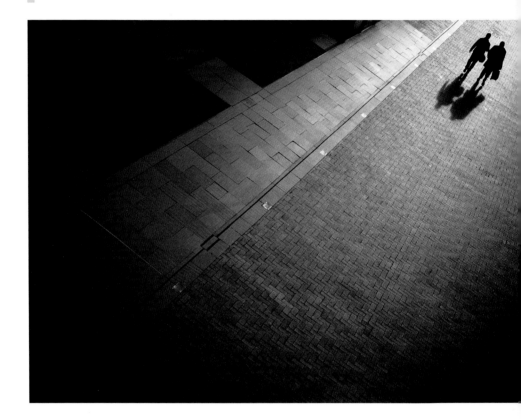

LOOK FOR PATTERNS FROM ABOVE

Silhouettes go hand in hand with street photography. Finding an irregular pavement surface will add an extra dimension to your photograph. Next time you are in an elevated position and spot an interesting road surface, take a photo and see if it affects the way light is shown in the image. In the photo above, the light bounces off the floor, reflecting off the paving stones in different directions.

CAPTURE THE GREATEST SUNSETS

· ·

Sunsets are magical – it's no wonder they have inspired generations of painters and photographers. Rather than focusing solely on the explosive colours in the sky, look for some foreground detail, such as

trees, buildings, or even people, to create a compelling silhouette. As long as you ensure the sun sets behind your subject, you should get an interesting shot.

N THE FRAME

· ·

n this night shot, the cyclist its the frame perfectly, and the ght emanating from a shop window creates the silhouette.

ry choosing your shot, framing it at n angle, then simply waiting for the ight moment to press the shutter.

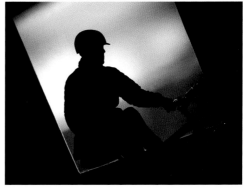

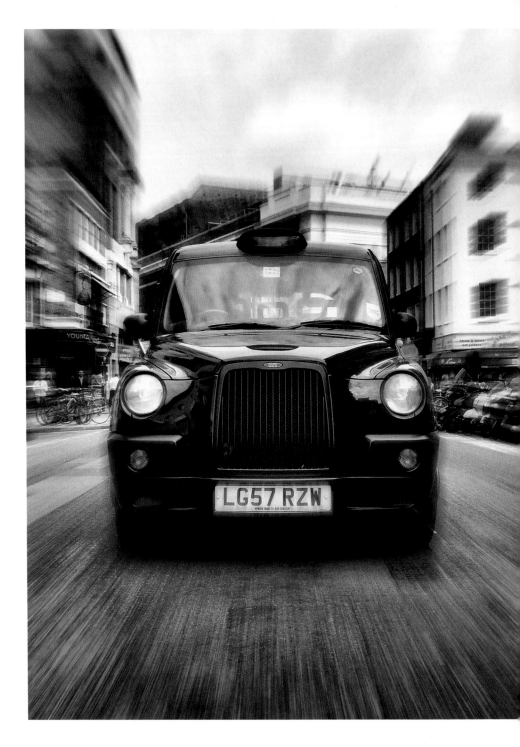

THE WORLD IN MOTION

So, how can you communicate a sense of movement through your photograph? The answer is to step out of your comfort zone and exit the default mode or automatic settings that you might find on a camera or phone. Whichever you use to take your photos, refer to your instructions and begin experimenting with manual settings.

When a camera or phone are set on automatic mode, they are programmed to capture a sharp image with the subject 'frozen' in motion. To achieve this, they will need to use a very fast shutter speed (think blink of the eye), to capture only that split second.

Slowing down the shutter speed (S or shutter priority setting) allows you to capture a slightly longer slice of time and therefore more light. This will appear in the photograph as a light trail behind the subject, or a 'motion blur', which shows all the movement that took place during the time the shutter was open.

Whether you use a phone or camera, refer to your instructions and begin experimenting with manual settings.

69

GET THE SHOT

1. CHOOSE THE BACKGROUND

The background in a photograph is key and, if you find the right one, you can even use its colours to your advantage. Here, the complementary colours of the person's clothes in the foreground echo the colours in the background.

A billboard, with pedestrians walking in front, can also provide a pleasing juxtaposition.

2. CHECK THE COMPOSITION

Having chosen a strong background, you can now experiment with various angles. In this shot, I decided to shoot straight ahead to keep the road, white line, pavement and wall all parallel. Notice also how the bottom of the colourful wall sits at about a third of the image's height, following the rule of thirds.

3. SET SHUTTER SPEED TO 1/60

In this shot, the shutter speed was just slow enough to capture the movement of the cyclist, but not so slow that it would also catch the movement from the photographer's body swaying a little or from breathing in and out. This would result in a blurry background.

Start with 1/60, then adjust either with a longer or shorter shutter speed until you are happy with the result.

4. CONSIDER USING A TRIPOD

A tripod is the easiest way to produce a sharp background with a blurred subject, as the camera will be completely still. That said, it is perfectly possible to capture a sharp background and a motion-blurred subject without a tripod; it's just a little more difficult.

For optimal handheld stability, space your feet apart, bring your elbows close to your body, and hold your breath just before pressing the shutter. Even better if you can rest against a wall, a lamp post or something sturdy.

5. EMBRACE THE COLOURS

There are many situations in which black and white seems the obvious choice to create mood and atmosphere. However, other situations call for one thing: colour. In this case, the colours are essential to the effect this photo has on the viewer.

> For optimal handheld stability, space your feet apart, bring your elbows close to your body, and hold your breath just before pressing the shutter.

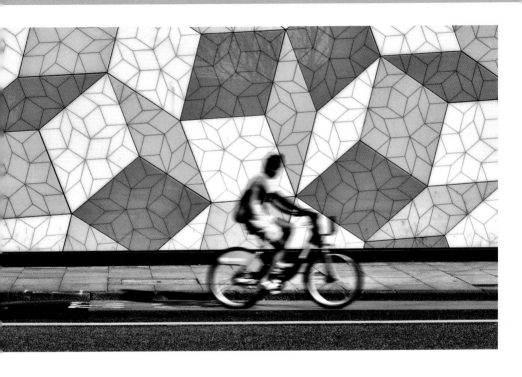

EXPERT TIP
.

Some of the best photographs have come to life after very long waits in one spot. It is vital to be able to spot opportunities and be quick to react to get the shot. These opportunities are often scarce, so we wait, with the composition ready, for the right passer-by. If we settle for the first shot and leave, we may miss a perfect shot a minute or an hour later. When that moment comes, we must ensure we are ready and know our camera well enough to get the shot.

You can completely change the look of a shot by altering your <u>shutter speed</u> and creating motion blur.

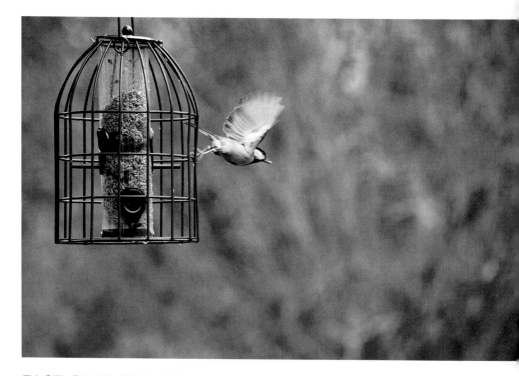

FAST OR SLOW, IT'S ALL RELATIVE

This image was shot at 1/500th of a second. If it had been a photograph of a person walking, that would have been a fast enough shutter speed to completely freeze their (much slower) movement. In this case, the movement of the bird is so rapid it still doesn't give a sharp image. The key is to practise with different levels of movement in order to become familiar with the shutter speed that best suits a particular subject. It will quickly become an instinctive part of the process.

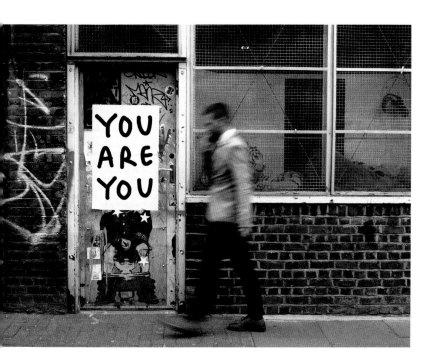

USE MOTION BLUR TO REMOVE DISTRACTIONS

When using motion blur, figures can take on an almost ghostly appearance, allowing the viewer to focus on the background. Use slow shutter speeds if you do not want pedestrians to be the main point of focus in your photographs. It's possible to remove people almost completely from a landscape by using very slow shutter speeds, which will spread the motion blur to almost nothing.

CREATE A ZOOM EFFECT

Here, it is the photographer who moved and not the subject. Set the shutter speed to 1/60 and, if you are using a zoom lens, rapidly twist the zoom as the shutter is pressed. If you are using a phone or fixed focal lens, rapidly thrust the camera towards the subject as the shutter is pressed. This creates a hyper-dynamic zoom effect.

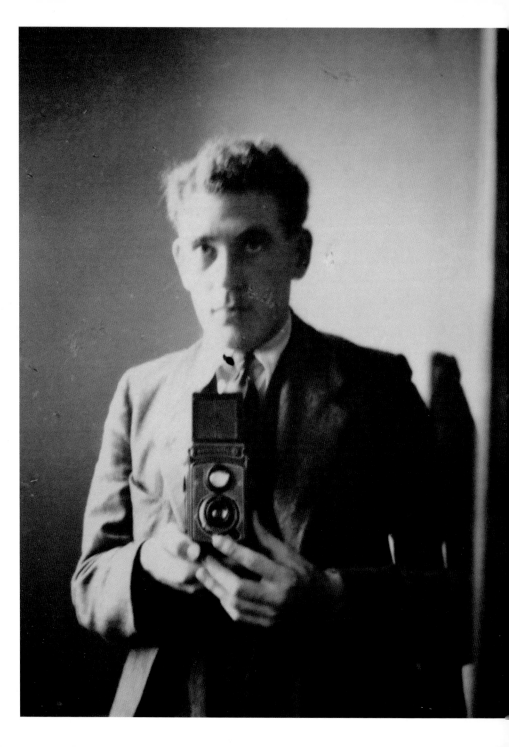

THE UNSELFIE

Selfies. Like them or not, most people have experimented with them at some point. Camera owners have had the desire to photograph themselves since the birth of photography in the late 19th century. That's quite some time before the word 'selfie' officially made it into the dictionary.

Selfies needn't mean limiting yourself to holding your phone with your arm extended. Instead, they are just another door to expressing your creative side. The examples which follow will show you what can be achieved by thinking a little outside the conventional arm's-length shots, seeing things differently and experimenting.

One of the best ways to up your selfie game is by using a tripod and the timer on your camera.

This allows more flexibility in angles, poses, backgrounds and, generally speaking, allows for greater creative expression and prior composition.

Camera owners have had the desire to photograph themselves since the birth of photography.

GET THE SHOT

1. MORE THAN A SELFIE

When shooting a selfie, it is possible to make it about so much more than just you. For example, introduce reflections in your selfies. In this case, sunglasses are used, but shop fronts in urban areas, buildings, windows, mirrors, curved reflective surfaces and puddles are all instruments in your creative toolbox.

2. DON'T JUST STOP AT THE FIRST ATTEMPT

Anyone can create an amazing selfie with nothing more than a phone. Make repeated attempts until you find a winning shot. Change angles, background and light intensity. For every good photo, there are many bad ones. It's easy to look at social media and only see the amazing photos people post, but remember, only the best photos have been picked from a wider selection that were shot.

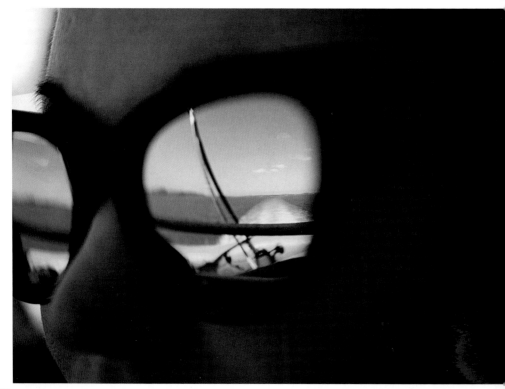

3. A BLURRY PHOTO OF SOMETHING IS BETTER THAN A SHARP PHOTO OF NOTHING

When taking photos, even the pros produce technically imperfect images in which perhaps the focus is a bit off or the shutter speed too slow creating motion blur. Don't be too quick to dismiss photos that don't achieve 100% technical perfection. Life goes fast and sometimes what we experience happens so fast that it can be a bit of a blur. Capturing life needn't always be perfectly sharp; it's how an image can convey a feeling that matters more.

4. DON'T BE AFRAID TO USE FILTERS

We're not referring to so-called beautifying apps. Your camera or phone will probably have built-in colour and effect filters. If they don't, you can use an app to edit the photos after you've taken them, such as Snapseed or Photoshop. Experiment freely with these to try to achieve a different look or feel to your photos. Some filters will inject a bit of vintage into your photos, while others will give a cool cinematic look. While striving to get the best shots straight out of a camera should be any photographer's goal, playing with and editing your photos can be just as creative as the act of taking the photograph itself.

5. MAKE USE OF YOUR BACKGROUND

If you are surrounded by beauty or something of interest, shoot the photo so you feature in part of the image, but allow the surroundings to shine through and be seen. In this image, you can't tell if it is more about the person who took the selfie or the landscape they're looking at, and yet it is still a selfie.

Capturing life needn't always be perfectly sharp; it's how an image can convey a feeling that matters more.

With a little inspiration you can (transform) your simple selfies.

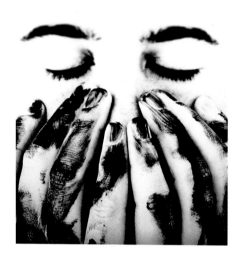

ACHIEVE A STUDIO LOOK ON THE CHEAP

This portrait was shot in the most unimpressive way: in a tiny flat's corridor, using cheap face paint, a tripod, a stool to sit on and no flash.

Hands were painted with black and gold and the chosen composition was tight, with the face filling the frame. With the camera on a tripod and the timer set to five seconds, all that was left was to press the shutter and place hands on face.

The image was then opened in a free editing app and two edits were made. The brightness was increased drastically to create the high-key look (an image with lots of light and white tones) and to smooth out minor facial features. The contrast was also pushed up.

TAKE TIME TO REFLECT

Reflective surfaces are all around us. Seek some out and see what unusual reflection of yourself you can capture.

This one is inspired by Vivian Maier, an American photographer whose spectacular photographs were found only after her death. She instantly gained posthumous acclaim for her street photography. Her work had a strong emphasis on self-portraits she shot in shop mirrors but in which she often only comprises a small portion of the whole image.

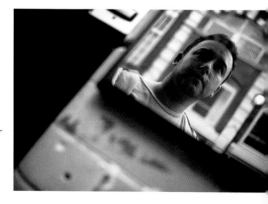

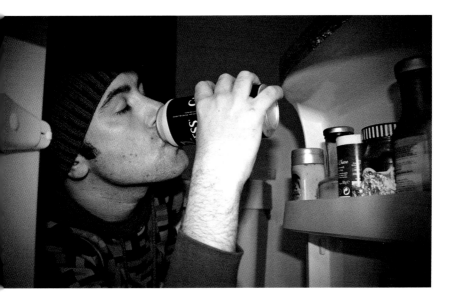

CAUGHT IN THE ACT

This shoot's a fun one you can achieve in all sorts of ways and places, giving an impression of a surveillance camera and resulting in a 'caught-in-the-act' shot.

In this case, a fridge was chosen (it offers great light!), but you could also use a cupboard. Place your camera as deep inside as possible to ensure a wide view (you need the option of seeing what you are creating, so either use the front camera on your phone or a tilt-screen on your digital camera.

Set the timer so you can pretend you're being caught unawares.

PLAY WITH SHADOWS

What defines a selfie? Does it have to show your actual face or body? Or can it be more abstract and suggestive? Shadows are a great way to capture your image in an alternative way. Often, the best shadows are the elongated ones, created by morning or evening light, or by winter light when the sun is low.

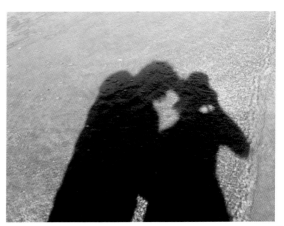

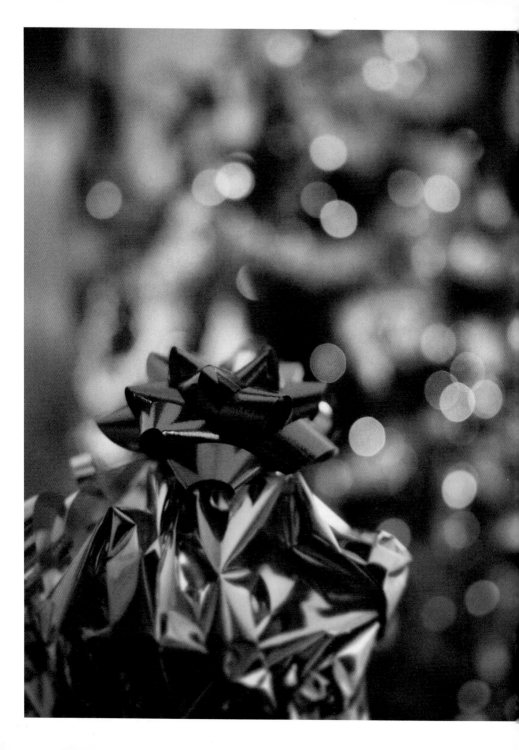

BLINDED BY THE LIGHTS

A BEGINNER'S GUIDE TO BOKEH

Put simply, 'bokeh' is the quality of the blur, or the beauty of the out-of-focus part of an image. Often associated with light sources, the effect is most visible around highlights, where it diffuses light and almost distorts the image. But bokeh isn't limited to brightly lit parts of an image – it is visible in every out-of-focus area. It can also be highly variable, as every lens has its own bokeh 'signature'.

To create images with bokeh you will need to explore depth of field, which is the element that dictates blur. You can experiment with depth of field by adjusting your lens aperture settings. A shallow depth of field will result in a narrow area in focus, with lots of blur outside of that area. A deep depth of field will result in almost everything in the image being in full focus and perfectly sharp.

To achieve a deliberate high-blur effect, use your camera or phone's aperture mode (A) and reduce the f-number to the minimum. Many cameras go down to f2.8, which allows for a large out-of-focus area. Remember, a high f-number means everything in focus, a low number means plenty of blur.

Once you master how to control the level of background blur, you will open the door to a world full of creativity.

Bokeh isn't limited to brightly lit parts of an image.

GET THE SHOT

1. SEARCH FOR SOME SPARKLE

For bokeh to reach its full potential, it helps to have a reflective element, at least in the background.

Here, the sparkle is provided by raindrops in the sunlight. The light is diffused and enhanced by the blur, creating the magic effect you're looking for.

2. GET CLOSE TO MAXIMIZE BLUR

One of the easiest ways to achieve a high level of blur, without delving deep into settings or using an expensive lens, is to shoot close-up. This is a foolproof way to create an image with only a small area in focus, while the rest bathes in blurry goodness.

Get down to the height of your subject and focus as closely as possible (until your camera just won't focus anymore). In this instance, pick a rain drop at the centre of your frame. Whatever is outside of the focus area should appear very blurred.

3. EXPLORE MULTIPLE ANGLES AND TAKE MANY SHOTS

As with everything in photography, bokeh is affected by light. Don't settle for a single shot from a single angle – your subject is three dimensional and should be observed that way. In this case the subject is backlit at a slight angle, so the light travels across the raindrops, giving them maximum shine.

4. PLAY WITH COLOUR SATURATION

One of the easiest settings when it comes to image editing is colour saturation. You will find an easy way to adjust it in any free image-editing app. In this case, the saturation was slightly reduced to complement the intended mood.

Don't settle for a single shot from a single angle, your subject is three dimensional and should be observed that way.

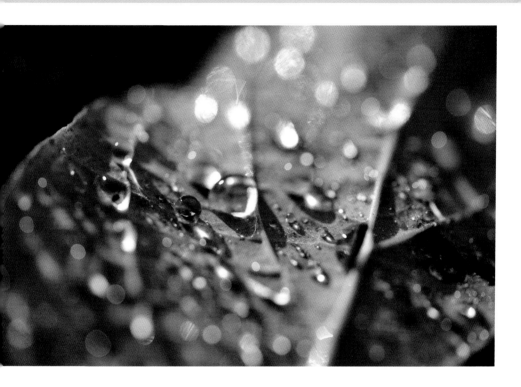

EXPERT TIP
.

Varying levels of bokeh can be created with any phone or camera lens combination. Regardless of your photographic equipment, in order to maximize your chances to capture that dreamy, soft blur surrounding your subject, get as close to your subject as your lens will focus. At the same time, increase the distance between the subject and the background. This will create the most bokeh, since this technique increases the blur between subject and background.

Bokeh is one of the <u>most popular</u> techniques in photography, and is used in many different ways.

URBAN EVENING LIGHTS

. .

In this image, which feels very cinematic, the bokeh applies to the background city lights. Their rusty tones match the fallen leaf which has lost its chlorophyll to reveal autumnal yellows and reds.

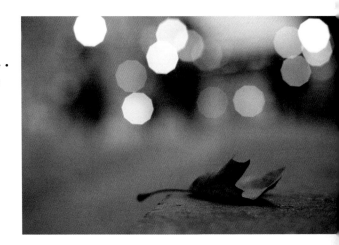

TURN THE ORDINARY INTO EXTRAORDINARY

.

Bokeh is so effective that it's possible to turn any object into a work of art, even the humble clothes peg. Choose something completely mundane and give it the bokeh treatment to see if you can elevate it.

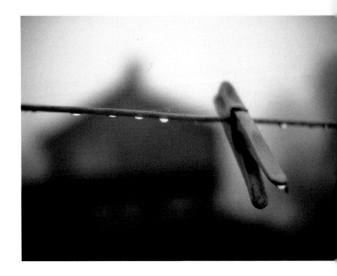

BACKGROUND DISTANCE MATTERS

When shooting portraits, you will obtain the highest level of blur by placing yourself closer to your subject than your subject is to the background. To increase the blur behind your subject, move them further away from the background and, if you can, move closer to them.

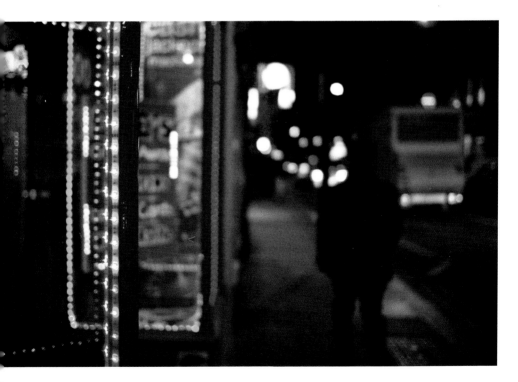

EMBRACE THE NIGHT

Bokeh adds atmosphere to night-time street photography. Lean sideways against a shop front and focus your lens on the wall or a foreground object as closely as possible. See how the background city lights look.

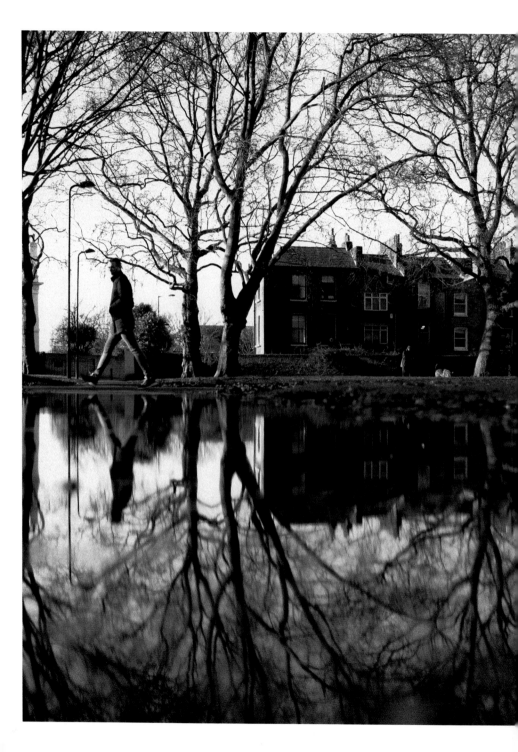

MIRROR, MIRROR

Symmetry and reflections surround us. Symmetry seems to appease an innate human need for balance. It is omnipresent in nature, from the symmetry of a butterfly's wings to the symmetry of a snowflake.

Outside of the natural world, symmetry is often found in architecture and urban design, inspiring the way our cities are planned and built.

Symmetry can be used as a tool by the photographer to help the viewer enjoy a photograph through the harmony it creates.

Reflections can be found in everything from puddles and lakes to windows, mirrors and car bonnets. They provide you with an easy way to find symmetry if you get very close to the point of reflection. Reflections also give us an alternative way to capture and show the world around us, providing the photographer with yet another tool with which to surprise their viewers.

Outside of the natural world, symmetry is often found in architecture and urban design.

GET THE SHOT

1. CHOOSE A CLEAN REFLECTION

When capturing reflections there is no point using a dirty mirror or window to reflect part of your image. It is the equivalent of using a dirty lens. It can be useful to carry a cloth so that you can wipe any surfaces you want to use in your photo.

2. TO ACHIEVE SYMMETRY, GET CLOSE

"If your photos aren't good enough, you're not close enough," said renowned photographer Robert Capa.

To achieve the best reflection and symmetry, bring your camera right down to the reflective surface, as close as you possibly can. This will fill your frame with as much reflection of your subject as you can get.

If you are using a camera phone, you can get closer by turning your phone upside down, so the camera is even nearer the surface.

3. IF IT DOESN'T FIT, TILT IT

When it comes to reflections, you're often trying to squeeze twice the amount into the same-sized frame. Why not ditch the challenging flat landscape shot and try alternatives? In this case, a 45-degree angle was ideal.

4. WORK ON YOUR COMPOSITION

Creating symmetry through reflection will also help with composition. In this example, you could draw a line from spire to spire, which (conveniently) is perfectly perpendicular with another line you could draw on the original horizon. It forms a diagonally angled 'cross'. Here, both cathedral spires are aligned with opposite corners of the frame, giving the image a carefully constructed composition.

When it comes to reflections, you're often trying to squeeze twice the amount into the same-sized frame.

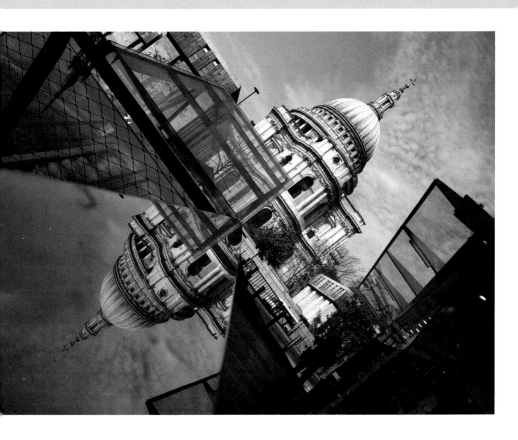

EXPERT TIP

· · · · · · · · · · · · · ·

Clear, empty, blue skies are not a photographer's friend unless you aim for minimalism. If you consider the proportion occupied by skies in a photograph, it would be wasteful to only feature blue skies when beautiful dotted clouds not only add interest but are also unique and impossible to reproduce exactly. This can add originality to your work. Pair them with reflection and you are on to a winner.

Reflections, and the sense of symmetry they create, are beautiful, and once you start looking you will see they're all around us.

EMBRACE ARCHITECTURAL REFLECTIONS

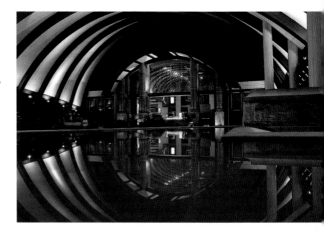

Reflections can make any architecture or interior look bigger. This reflected scene makes semi-circles join into a striking eye shape. Look out for water near an interesting bit of architecture, get very close and see what you can capture. Night photography works really well when paired with reflections, too.

THERE ARE TWO SIDES TO EVERY STORY

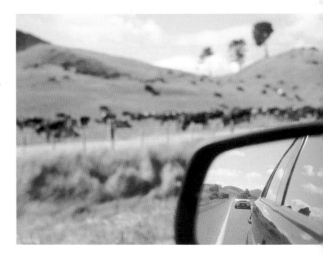

Use mirrors creatively to capture what's behind you and in front of you at the same time. This gives a sense of location – if the view alone had been shot from the car window there would be no sense of the car or suggestion of motion.

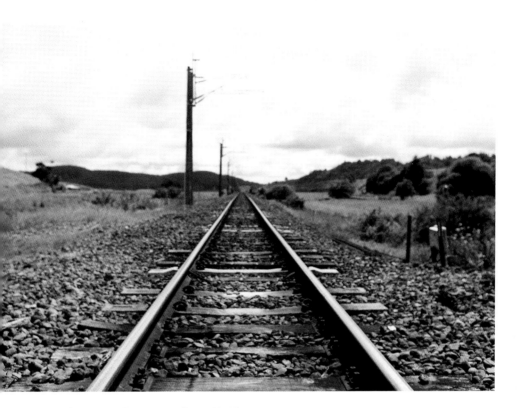

LEADING LINES AND SYMMETRY

Look out for human influence, such as leading lines, in a landscape, as they can offer opportunities for symmetry. It is possible to use them not only for balance, but also to guide the viewer's eye.

SEE LIFE THROUGH A PUDDLE

Puddles are an underrated photography tool. They offer clean, mirror-like reflections which are framed by both the edges of the puddle, as well as interesting textures from the pavement or whatever surface the puddle is on.

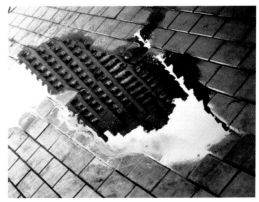

GLOSSARY

APERTURE

The part of a camera that light enters through. You can change the size of the aperture to allow more or less light to enter the camera.

AUTOMATIC MODE

Usually located on the dial situated at the top of a camera. Choosing this mode means the camera will take all decisions relating to settings for you. All you have to do is click. However, this also means less creative input from the photographer.

BACKLIT

When light comes mostly from behind your subject. 'Backlit' means you will be shooting toward the light. This can be challenging or, alternatively, used as a creative tool.

BLOWN OUT

When a picture is overexposed. For instance, often when taking photos on a bright day your subject will be lit correctly but the sky will be consequently 'too bright', losing its details, such as the clouds.

COMPOSITION

How everything works together within your frame. A good composition will be harmonious, and everything will seem in the right place. A bad composition can be messy, confusing and not enjoyable to look at.

CONTRAST

The difference between tones in a photograph. Contrast can be adjusted in post-processing using available apps on your phone.

CROP

Cropping allows you to adjust a photo's composition or format. For example, you may want to crop your image to a square format. It is the digital equivalent to taking a pair of scissors to a printed photo and cutting a bit off.

DEPTH OF FIELD

How much of your photo is in sharp focus. In the case of a landscape, a long depth of field will be preferred in order to see clear detail in the foreground and background. In a portrait, we often seek the opposite, a shallow depth of field, resulting in the face being sharp but the background immediately blurred. This helps the face stand out better.

DYNAMIC RANGE

Think of it as how well a camera deals with light vs shadows, and the detail in each. Often, cameras will not be able to get good detail in both, so the photographer needs to decide which they favour. This results in images where, for example, the whole scene is well lit but you cannot see detail in the shaded areas. The human eye is far more efficient at this than cameras.

EXPOSURE (LONG)

The length of time the shutter of the camera stays open, allowing light to enter. On a bright day, only a split second is needed to capture the light. In a dark setting, the shutter will need to remain open for longer. This is why night photography is hard, as the longer your shutter is open, the more likely you are to experience motion blur.

FOCAL LENGTH

A standard zoom lens will have a focal length of 24 to 70mm. 24mm is wide; it allows you to capture as much as possible within your frame. 70mm is zoomed in, which allows you to capture objects that are further away.

FOCUS

The area in focus is the area you decide is best captured the sharpest. For example, if you shoot a person you will often focus on their face or, even better, focus on their eyes.

FILTER

These used to only be physical circular devices you'd screw on to the end of your lens. Some help reduce glare, others act as a pair of sunglasses for your camera on bright days.

Today, filters often refer to 'effects' you can add on to a photo digitally, using editing apps on your phone. Some filters will add 'grain' on the image making it look vintage, other filters will add softness to the light and change the overall feel of a photo.

FRAME

Often refers to what one decides to include in the image. It is what you see on your camera screen or in the viewfinder or eyepiece before you take the shot. It is a preview of your final image.

F-STOP

Values noted as f2.8, f5.6 etc. that a photographer can set in order to control aperture. Aperture is the camera's iris equivalent of a human eye. A wide aperture (f2.8 is wide) will allow lots of light in, just like your eye would in a dark situation, with its iris wide open. Whereas a narrow aperture (f22, for example) will restrict how much light enters, like your eye would on a very bright day.

GOLDEN HOUR

Mornings or evenings, when the sun is low on the horizon and the light feels golden in colour.

LENS

This is the 'eye' of the camera. Lenses, whether fixed or detachable, allow the light to enter the camera and be recorded on the camera sensor.

MANUAL

In manual mode, photographers have total control on all aspects of a photo being taken. They decide which setting is the best. It is the opposite of auto mode, which removes all decisions from photographers and lets the camera decide.

MONOCHROME

Not in colour. Black and white is monochrome.

MOTION BLUR

When your image is blurry because you moved or were not stable enough when taking the shot. This can be avoided by using a tripod, for example.

PANNING

To go from left to right or right to left. For example, if you shoot a car driving by, you may pan to follow the car to get your image of it.

PERSPECTIVE

The way one sees things or the chosen point of view. It can be low or high, for example. Great photographers are experts at finding effective and different perspectives so their images stand out from the crowd.

RESOLUTION

How much detail is visible in a photograph. Often linked to megapixels, it is also connected to the size of the sensor within your camera.

SATURATION

How much colours 'pop'. Saturation is affected by light levels but also camera settings. It is possible to adjust saturation in post-processing using an app.

SHUTTER SPEED

The speed at which the shutter of the camera closes. The shutter speed is key to a good photograph. Too short a shutter speed will result in a dark photo as not enough light entered. Too long an exposure will result in a very bright, over-exposed image because too much light got in.

SLR/DSLR

Single Lens Reflex/Digital Single Lens Reflex. This pertains to cameras with interchangeable lenses, as opposed to phones that have fixed lenses. The benefit of a DSLR is the ability to purchase very specialized lenses, such as macro lenses or fisheye lenses.

TIMELAPSE

A video showing the passage of time. The video is made up of single images taken at regular intervals and played back rapidly. Timelapses could show a flower opening, clouds passing or a building being erected, for example.

VIGNETTE

A defect when you see the corners of the image 'darkened', or not as bright as the rest of the image. It happens with some lenses more than others. Vignetting can be used as part of a creative style a photographer adopts, and can be both removed or added in post processing using various photo-editing apps.

ZOOM

The ability to get closer to the subject you are photographing without moving forward but by using a zoom lens or the zoom on your phone.